BEGINNER'S GUIDE

TO

PERSPECTIVE

Victor Perard

V.P.

Horizon line

V.P.

DOVER PUBLICATIONS, INC.
Mineola, New York

Bibliographical Note

This Dover edition, first published in 2006, is an unabridged republication of the work originally published in 1957 by the Pitman Publishing Corporation, New York, under the title *Perspective.*

International Standard Book Number: 0-486-45148-8

Manufactured in the United States of America
Dover Publications, Inc., 31 East 2nd Street, Mineola, N.Y. 11501

FOREWORD

Perspective is the principle by which an object receding from the position of the viewer appears, to the viewer, smaller than its true size, and, conversely, an object approaching the viewer's position seems more and more to approximate its true size. The knowledge of perspective is an indispensable aid to the artist, who must represent on a flat surface subjects which, in actuality, exist in three dimensional space. As a test, take a ruler and measure a person forty feet away. As he approaches, see how much larger he seems to become. The test shows the apparent variation in size of an object, depending on its remoteness from or nearness to the viewer.

The vanishing point is that point on the horizon where parallel lines (perspective lines) seemingly converge and terminate. The vanishing point is always on the horizon. Any object within a picture will have perspective lines, though these lines are not visible in the finished drawing.

The horizon line is always on a level with the eyes of the observer, and it changes with the observer's changing positions, as shown in the drawings that follow.

The drawings in this book have been chosen to illustrate the variety of problems which the artist encounters when creating a picture. Study them carefully and then apply the principles which they present when next you make a sketch.

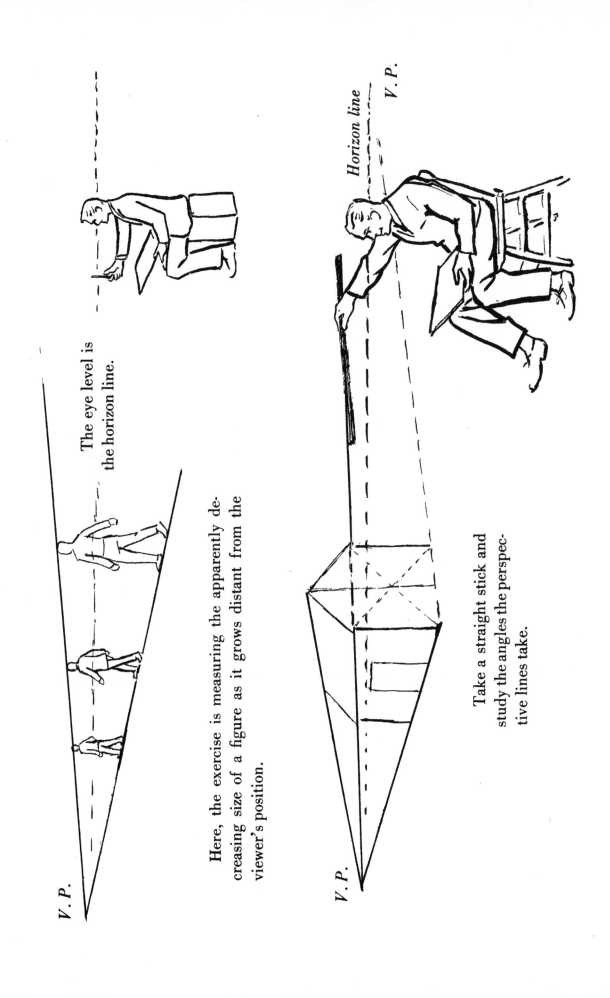

The eye level is the horizon line.

Here, the exercise is measuring the apparently decreasing size of a figure as it grows distant from the viewer's position.

Horizon line

V. P.

Take a straight stick and study the angles the perspective lines take.

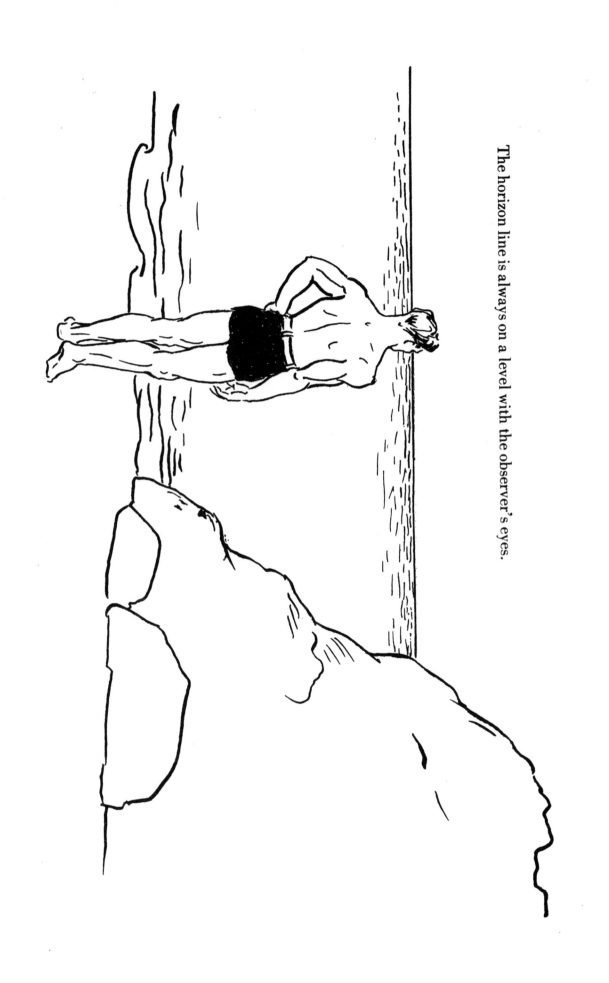

The horizon line is always on a level with the observer's eyes.

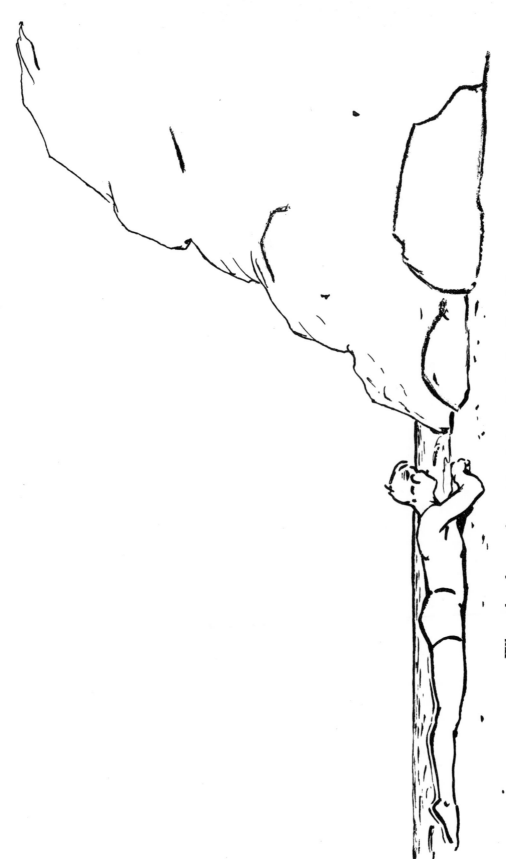

When the observer's position is low, the horizon line is low.

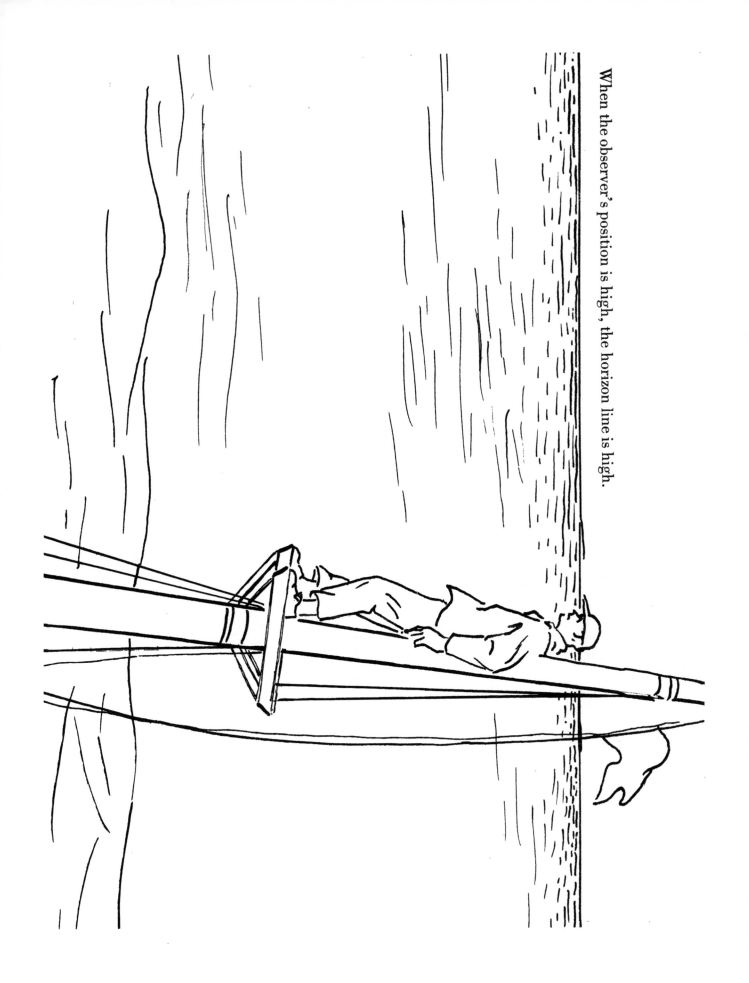

When the observer's position is high, the horizon line is high.

A beginner will draw a front view of a face with a profile of the nose and a side view of the face with a front view of an eye. He is drawing what he knows exists rather than what he sees. How deceptive is the length of a horse's head when it proves to be the length of a barrel. In perspective, objects are still more deceptive.

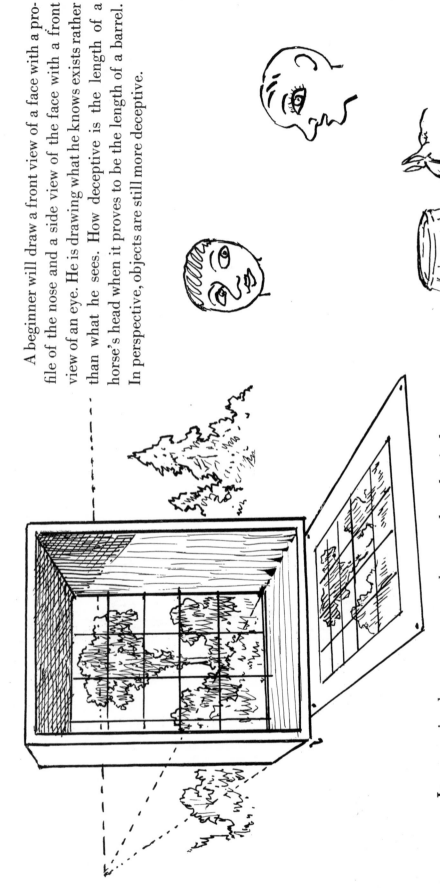

In a very simple way you can make a good mechanical aid to help you draw and visualize perspective accurately. Take a box, remove the bottom, and divide the open end into squares by criss-cross threads, as illustrated. Set up this frame in front of the subject to be drawn and note how the squares divide the picture. Draw squares on your paper, and copy what you see through each square in the box. You will find that you have drawn objects in perspective. That is, you have drawn what your eyes *tell* you exists, and not what your mind *knows* exists.

A square-paned window provides a framework of vertical and horizontal lines which helps to determine the angle of the perspective lines.

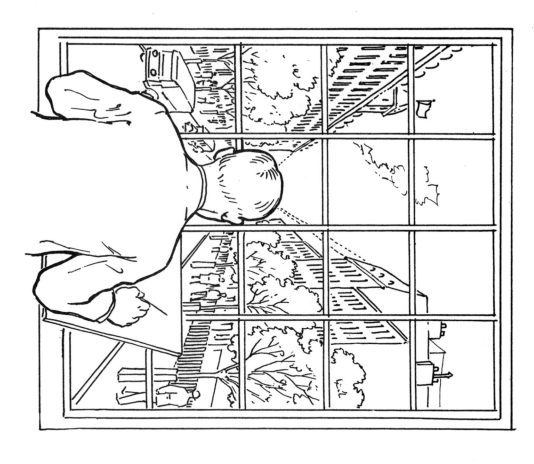

The vanishing point need not always be in the center of the picture. It may suit your composition better to shift it to one side or the other of the horizon line.

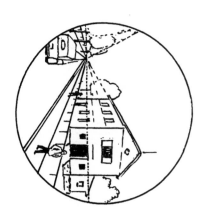 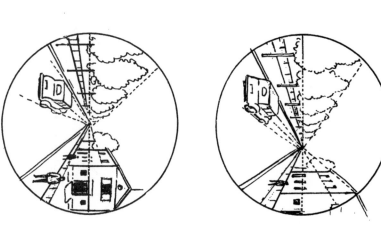

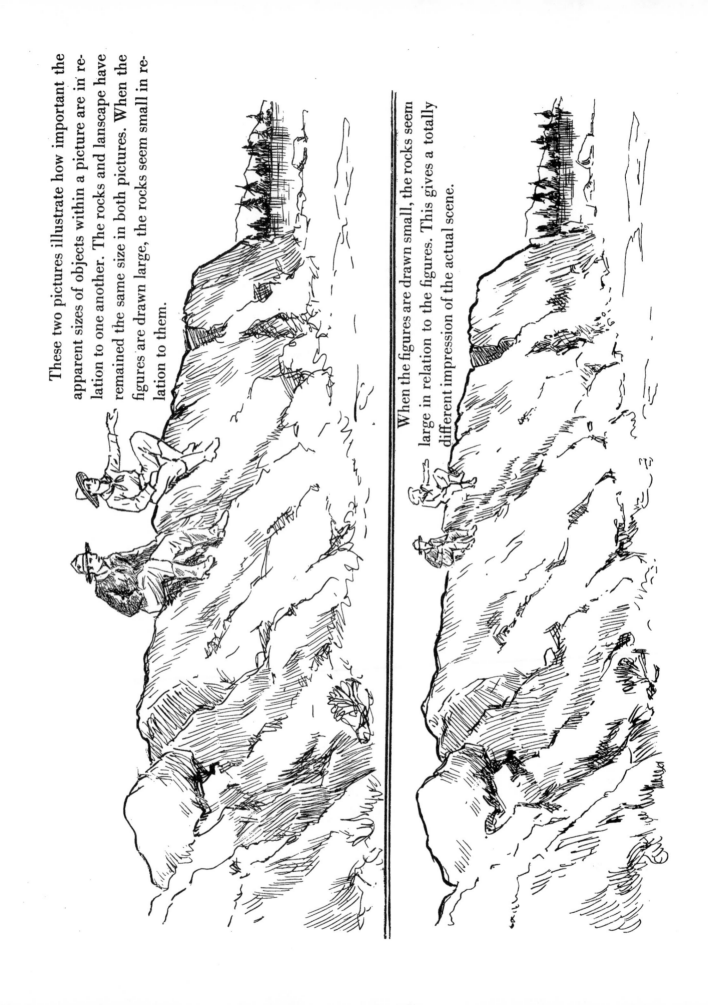

These two pictures illustrate how important the apparent sizes of objects within a picture are in relation to one another. The rocks and lanscape have remained the same size in both pictures. When the figures are drawn large, the rocks seem small in relation to them.

When the figures are drawn small, the rocks seem large in relation to the figures. This gives a totally different impression of the actual scene.

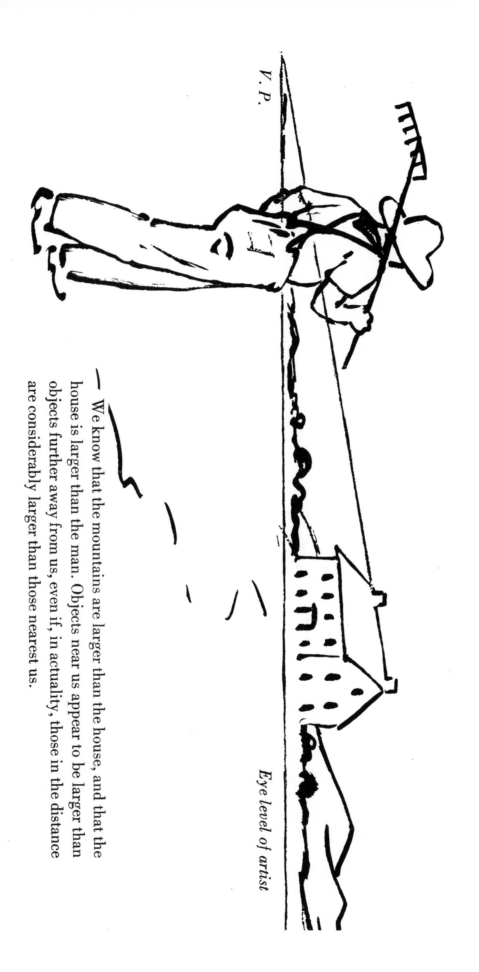

V. P.

Eye level of artist

— We know that the mountains are larger than the house, and that the house is larger than the man. Objects near us appear to be larger than objects further away from us, even if, in actuality, those in the distance are considerably larger than those nearest us.

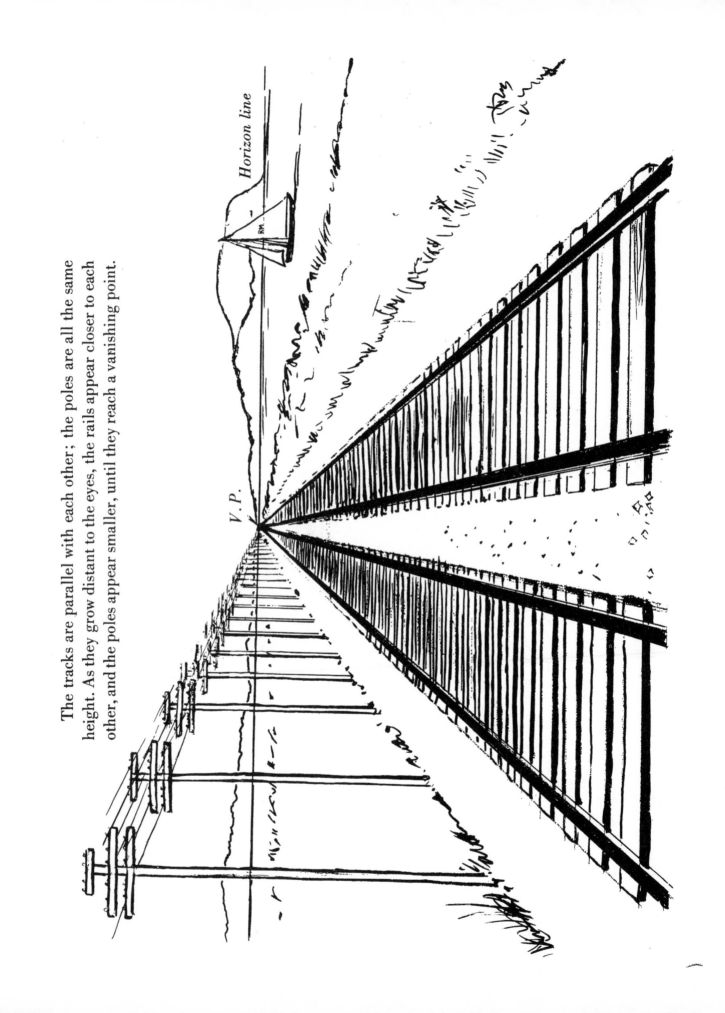

The tracks are parallel with each other; the poles are all the same height. As they grow distant to the eyes, the rails appear closer to each other, and the poles appear smaller, until they reach a vanishing point.

Horizon line

V.P.

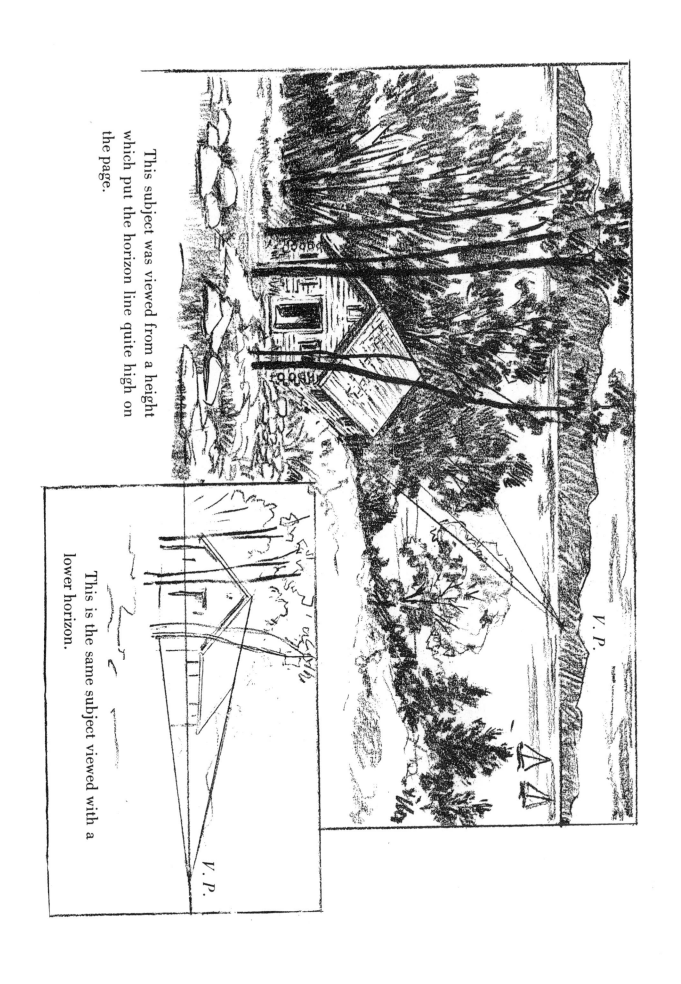

This subject was viewed from a height which put the horizon line quite high on the page.

V.P.

This is the same subject viewed with a lower horizon.

V.P.

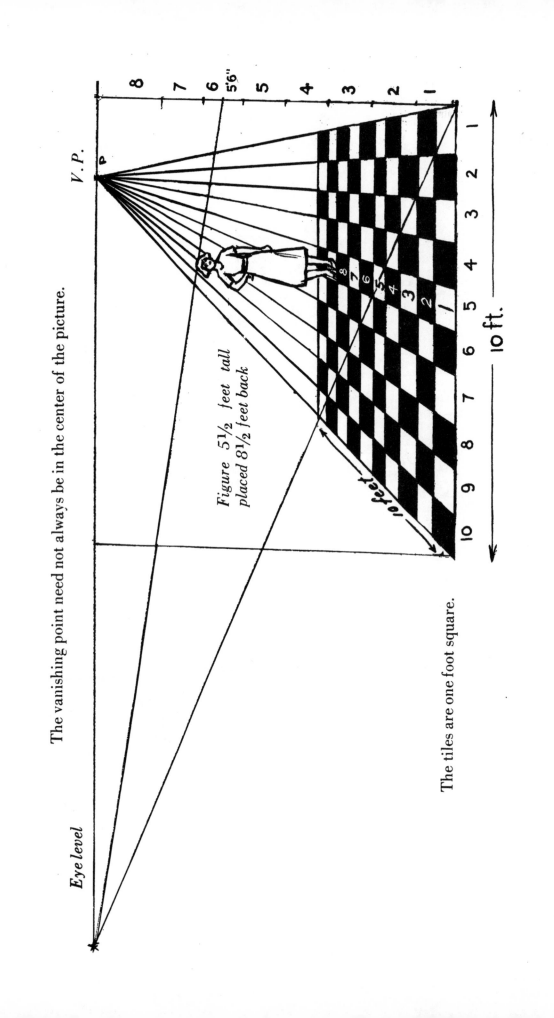

The vanishing point need not always be in the center of the picture.

V.P.

P

Eye level

Figure 5½ feet tall placed 8½ feet back

10 feet

10 ft.

The tiles are one foot square.

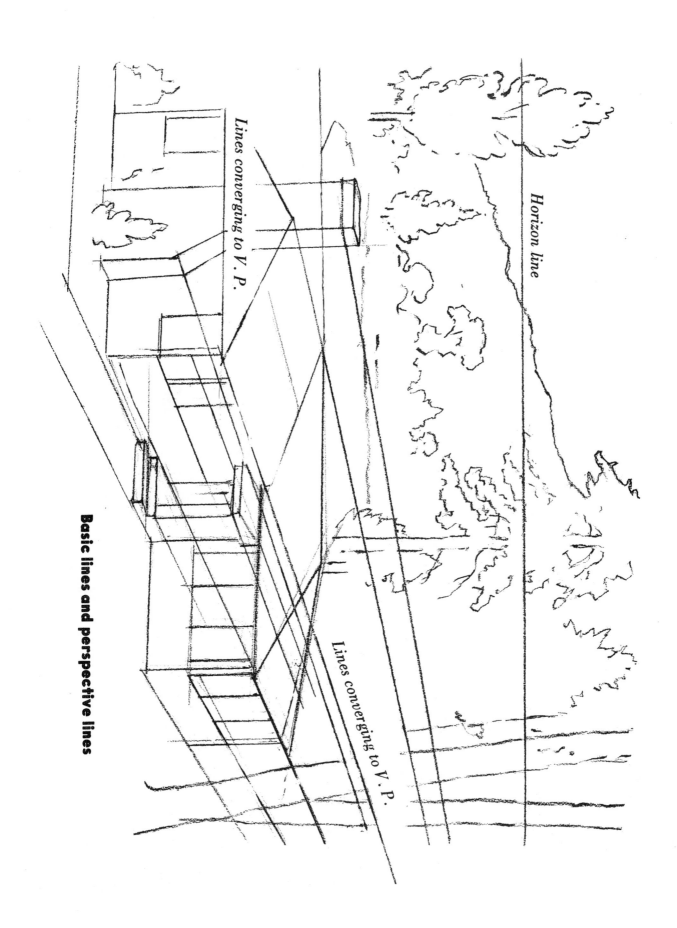

Horizon line

Lines converging to V. P.

Lines converging to V. P.

Basic lines and perspective lines

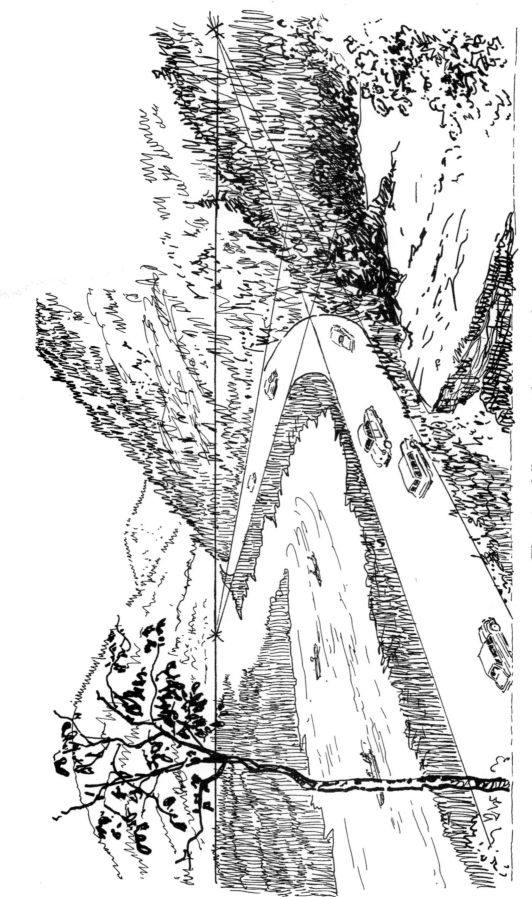

There is a different vanishing point for each curve of this winding road.

Here the problem is slightly more complicated, for there is a different set of vanishing points for each curve of the winding road going down hill.

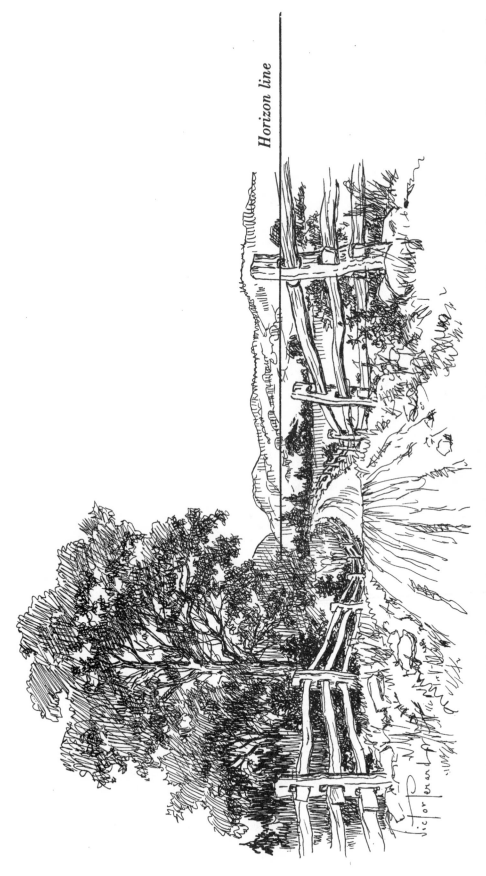

Horizon line

The problem presented by this ink drawing of a road going down hill, below the horizon line, is that the fence and the road take on different vanishing points for each of their curves. If the road and the fence did not dip and curve, they would all have one vanishing point.

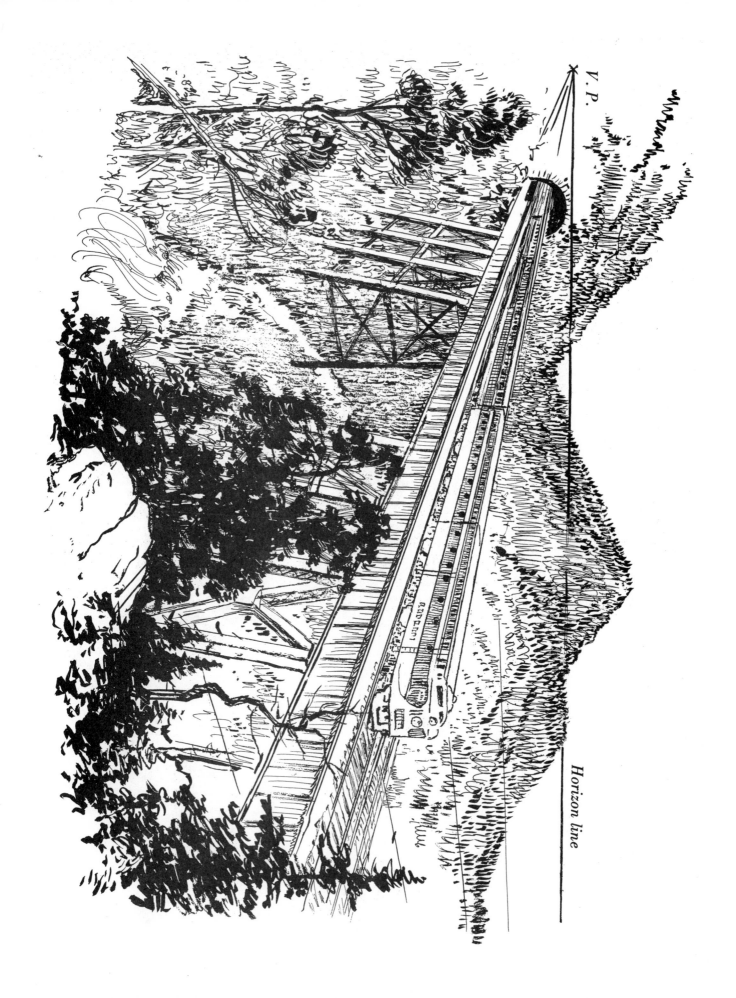

V. P.

Horizon line

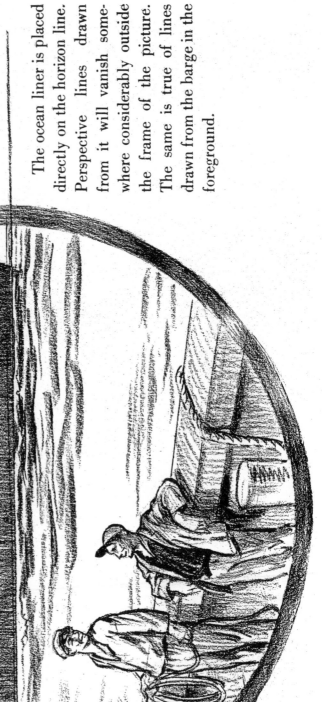

Horizon line

To V. P.

The ocean liner is placed directly on the horizon line. Perspective lines drawn from it will vanish somewhere considerably outside the frame of the picture. The same is true of lines drawn from the barge in the foreground.

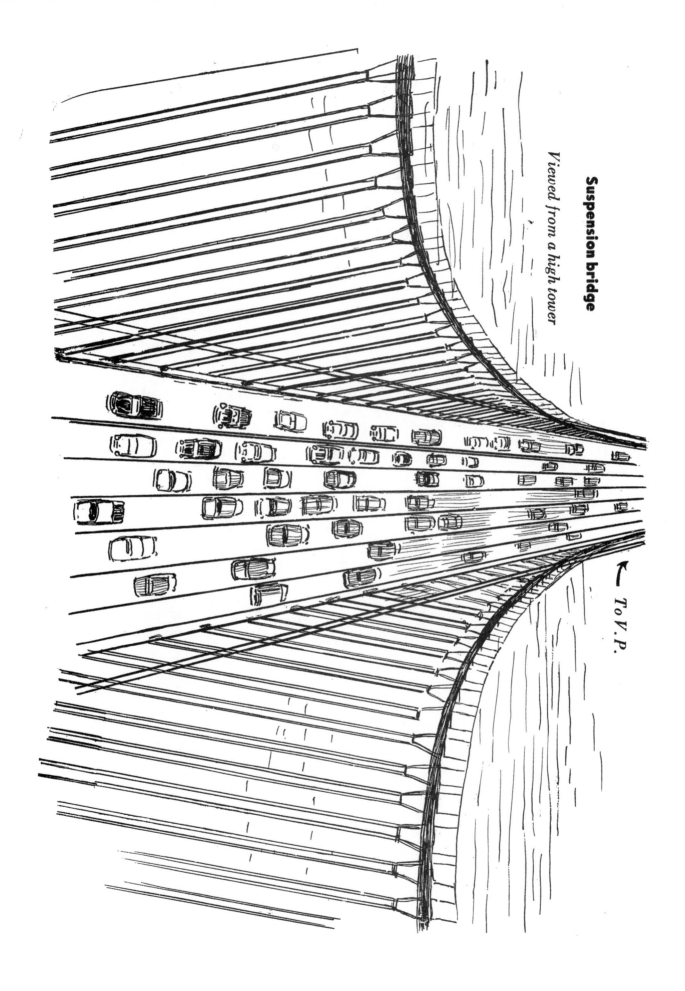

Suspension bridge

Viewed from a high tower

← *To V.P.*

V.P.

Horizon

V.P.

Eye level

V.P.

Objects in the same plane have many perspective lines which are not necessarily parallel to one another. We find that when the lines cease to be parallel, their vanishing points are variously placed on the horizon.

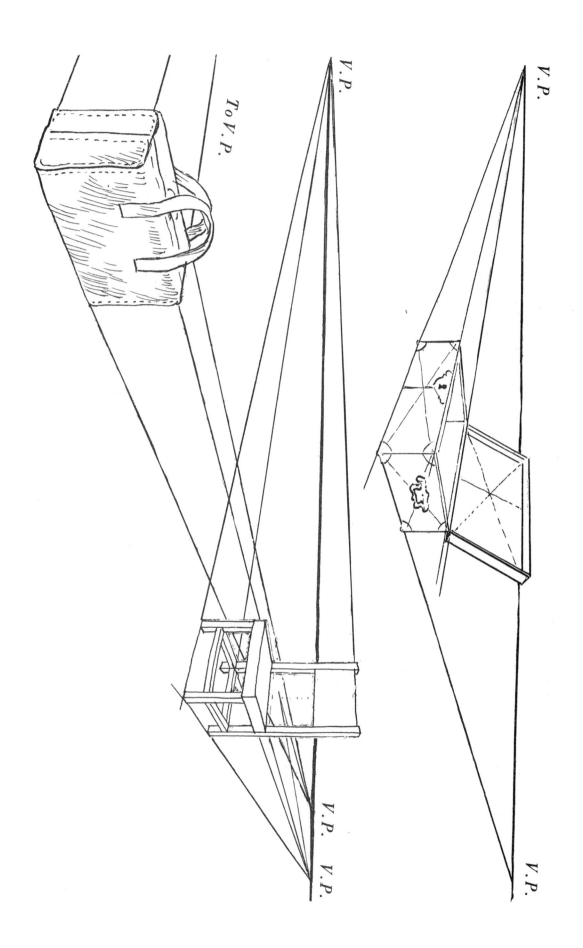

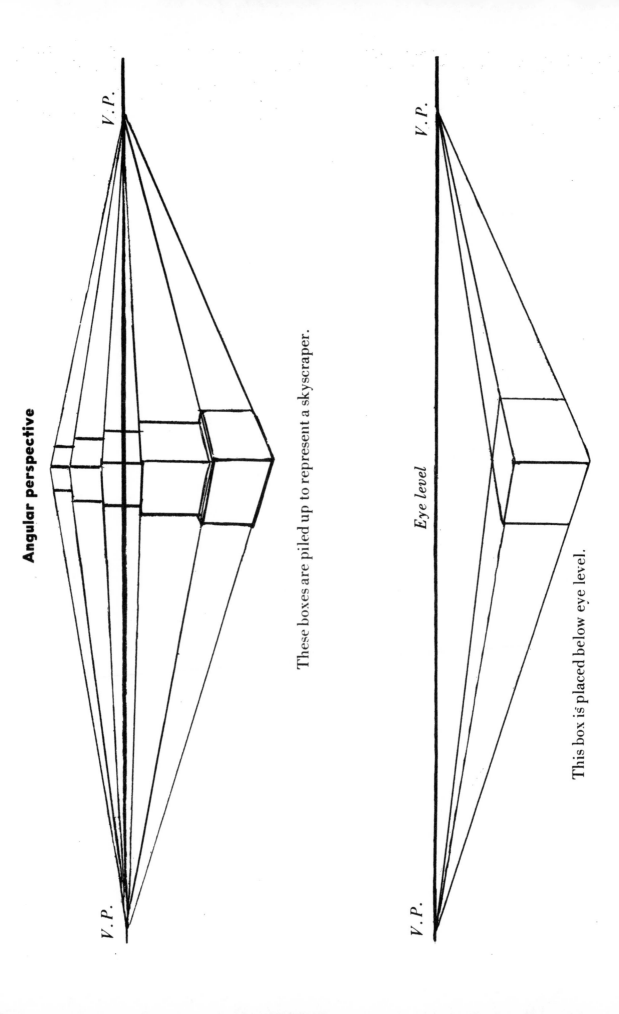

Angular perspective

V.P.

V.P.

These boxes are piled up to represent a skyscraper.

Eye level

V.P.

V.P.

This box is placed below eye level.

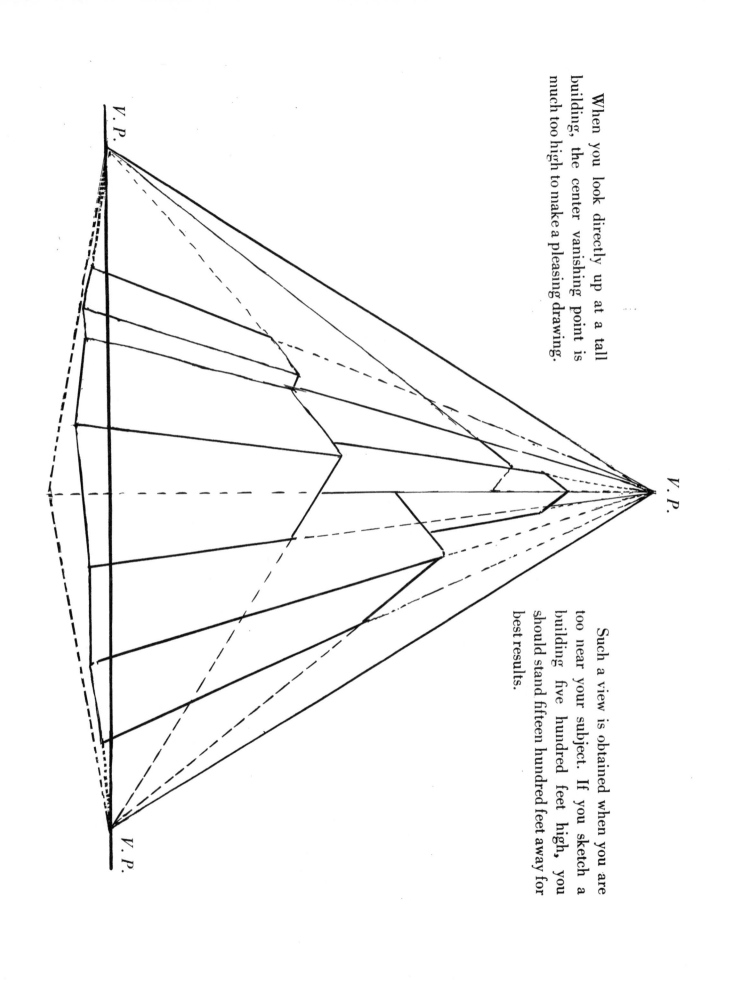

When you look directly up at a tall building, the center vanishing point is much too high to make a pleasing drawing.

Such a view is obtained when you are too near your subject. If you sketch a building five hundred feet high, you should stand fifteen hundred feet away for best results.

V.P.

V.P.

V.P.

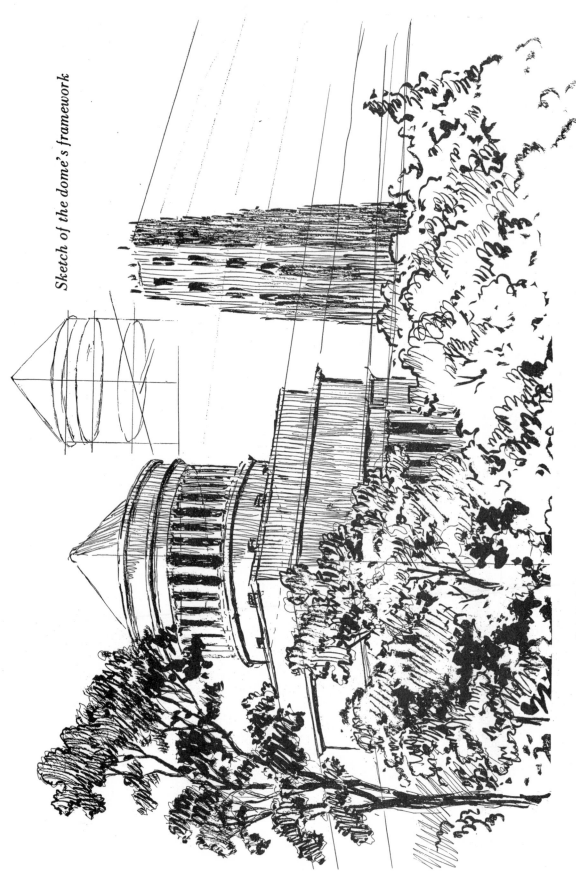

Sketch of the dome's framework

Grant's Tomb and Riverside Church in New York City

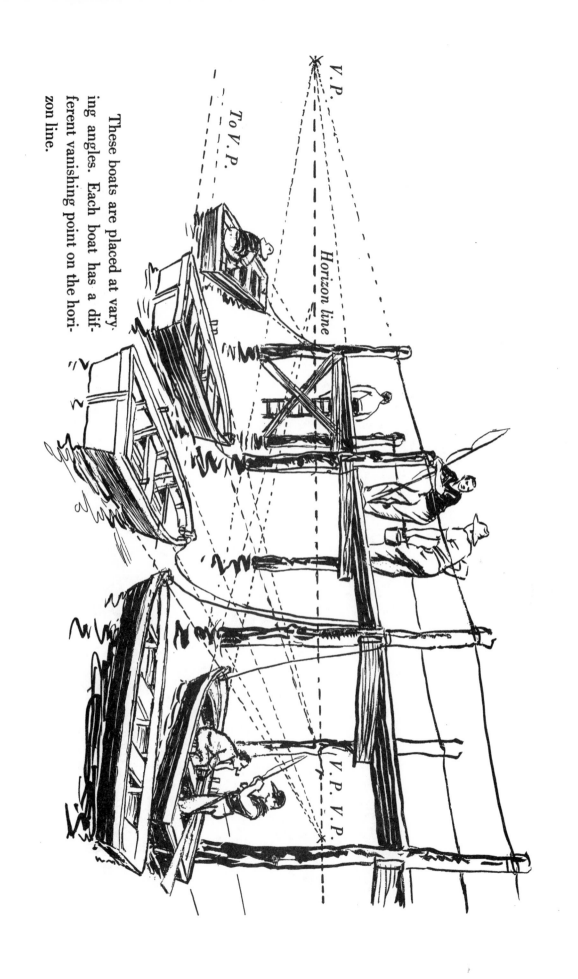

V.P.

To V.P.

Horizon line

V.P. *V.P.*

These boats are placed at varying angles. Each boat has a different vanishing point on the horizon line.

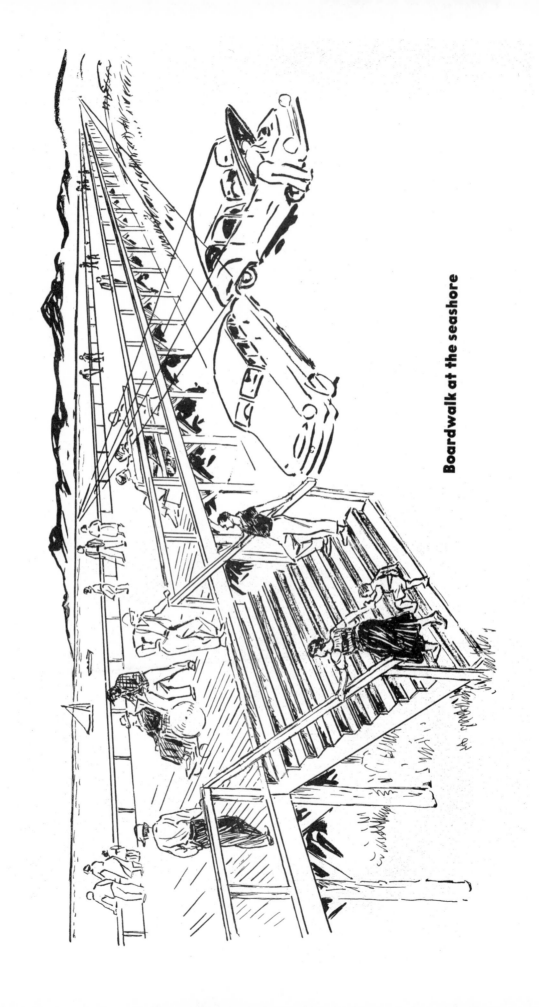

Boardwalk at the seashore

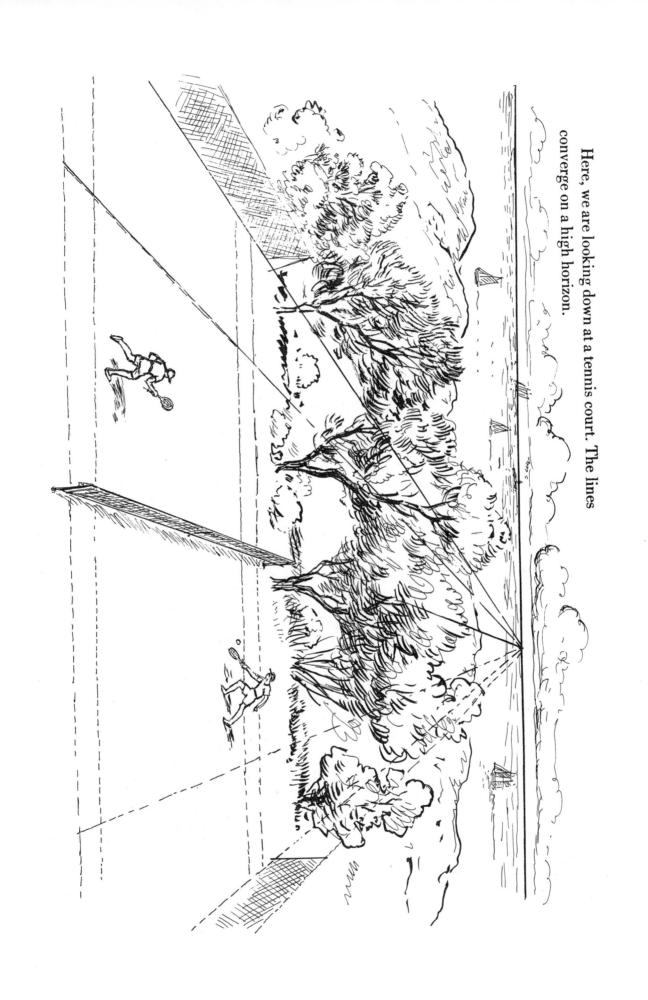

Here, we are looking down at a tennis court. The lines converge on a high horizon.

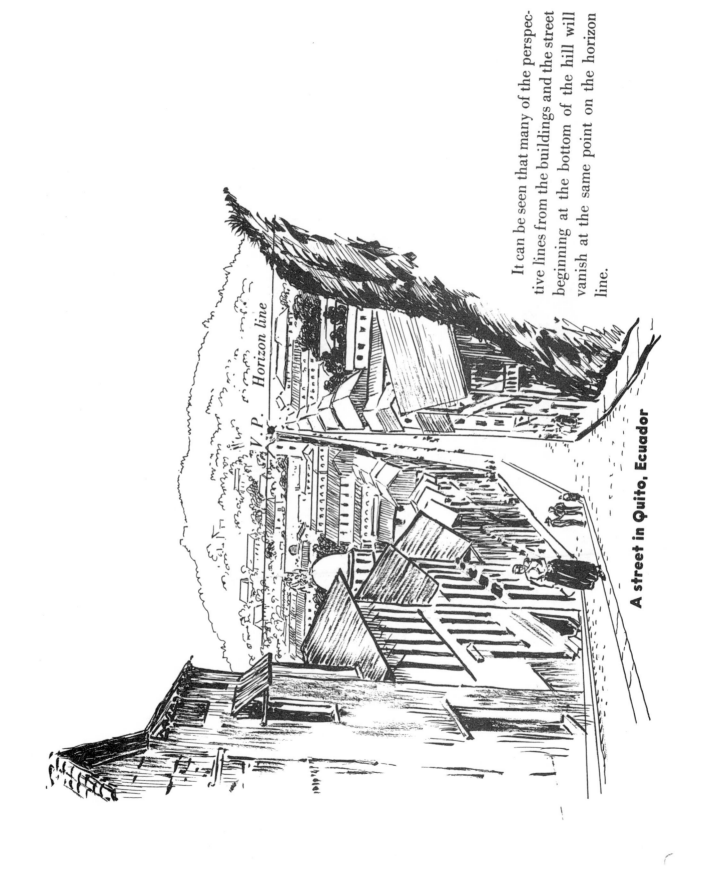

It can be seen that many of the perspective lines from the buildings and the street beginning at the bottom of the hill will vanish at the same point on the horizon line.

V.P. Horizon line

A street in Quito, Ecuador

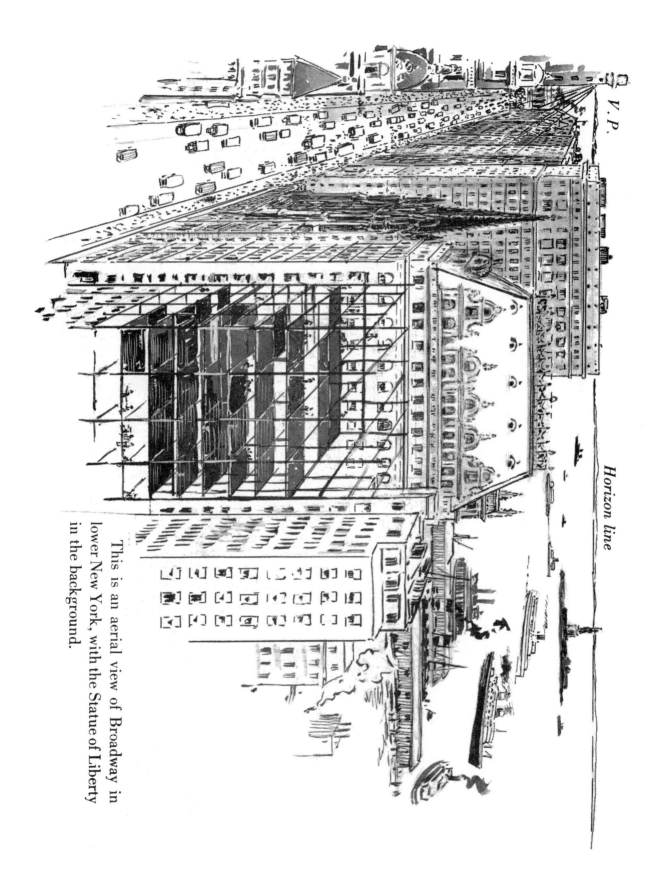

V.P.

Horizon line

This is an aerial view of Broadway in lower New York, with the Statue of Liberty in the background.

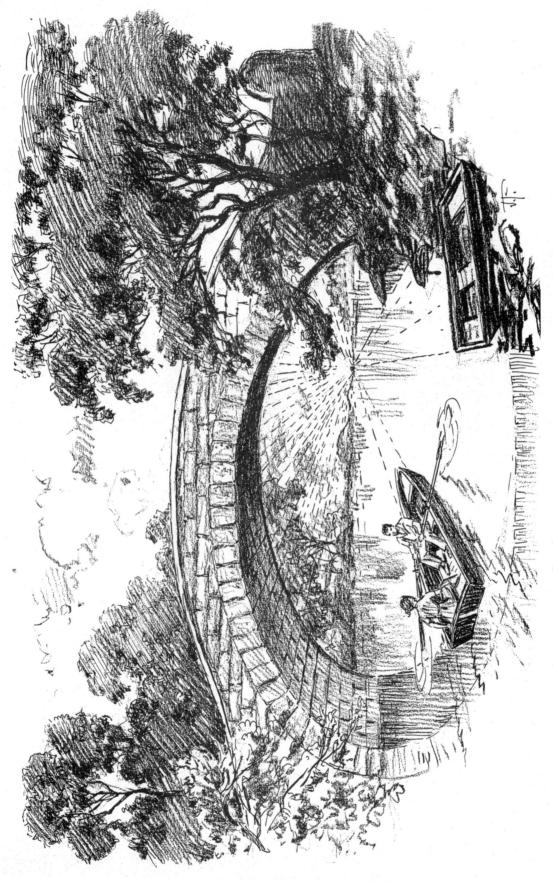

In this drawing the perspective guide lines all vanish at one point on the horizon.

Try the experiment of lifting a glass and observing the changes that take place above eye level, at eye level, and below eye level.

Eye level

A circle above or below the eye level diminishes as it approaches eye level. Therefore, a tall, cylindrical object, held below the eye level, will have a smaller ellipse at the top than at the bottom. The reverse is true of the same object held above eye level.

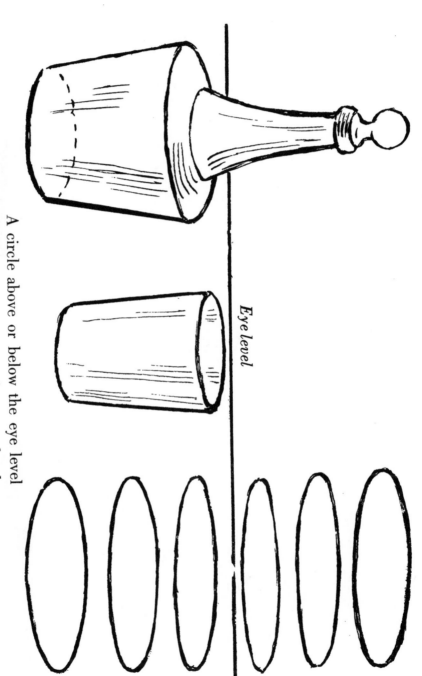

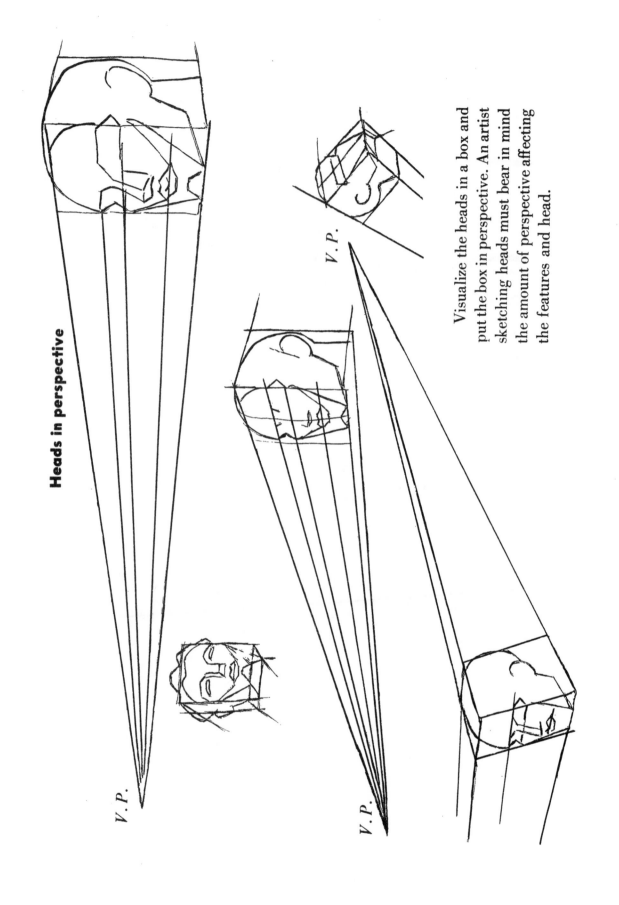

Heads in perspective

V. P.

V. P.

V. P.

Visualize the heads in a box and put the box in perspective. An artist sketching heads must bear in mind the amount of perspective affecting the features and head.

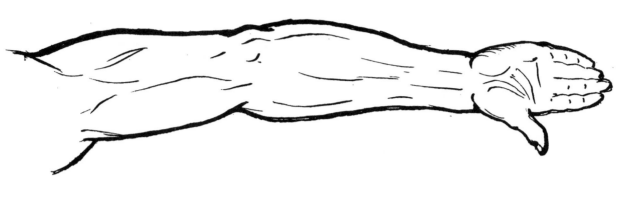

Arm straight up

Arm leaning backward

Arm stretched forward

Arm foreshortened

That part of an object nearest the viewer naturally seems larger than the rest of the object. This apparent distortion is called foreshortening, and is another aspect of perspective.

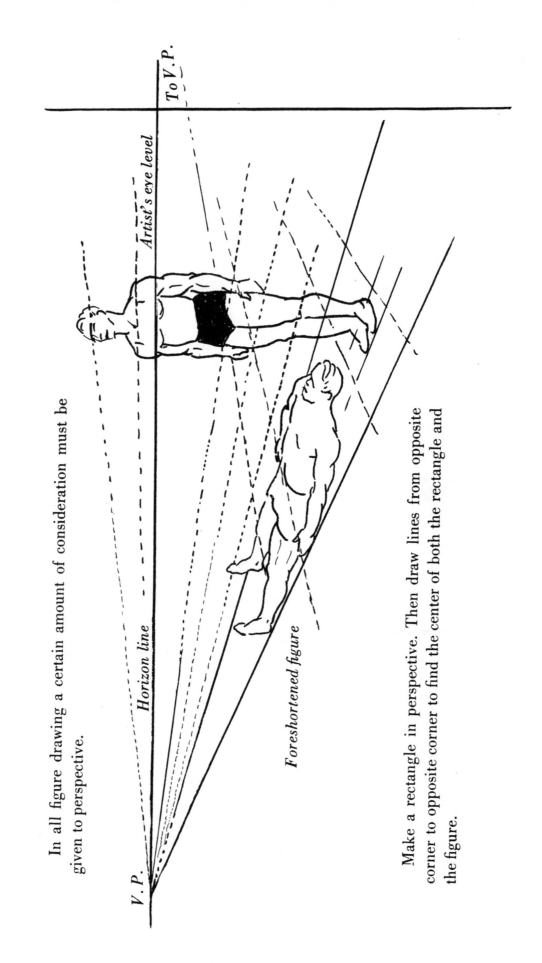

In all figure drawing a certain amount of consideration must be given to perspective.

Make a rectangle in perspective. Then draw lines from opposite corner to opposite corner to find the center of both the rectangle and the figure.

To V.P.

Artist's eye level

Horizon line

Foreshortened figure

V.P.

The center of each mat is obtained by drawing a line from corner to corner. The center is where the lines cross. This exercise helps in getting the foreshortening of the figures on the mats, because the figures, even though they may not appear to be, are also divided in half. It can be seen that the top half seems smaller than the bottom half.

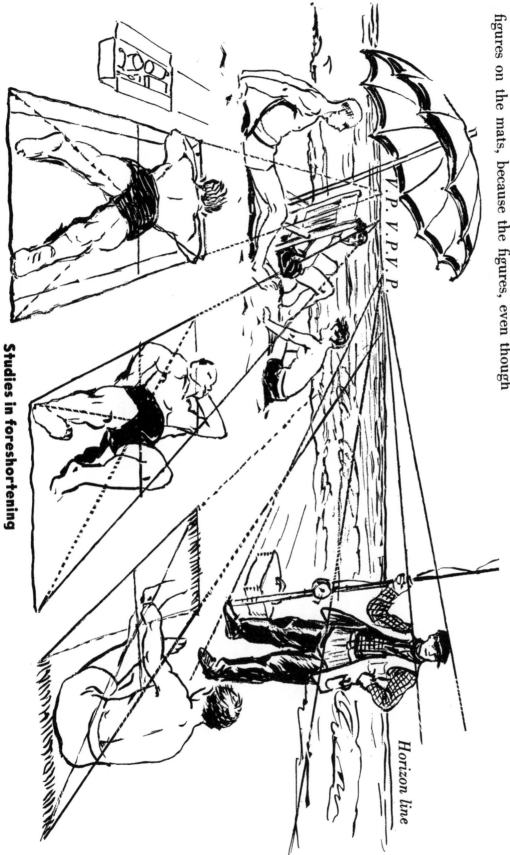

V.P. V.P.V.P.

Horizon line

Studies in foreshortening

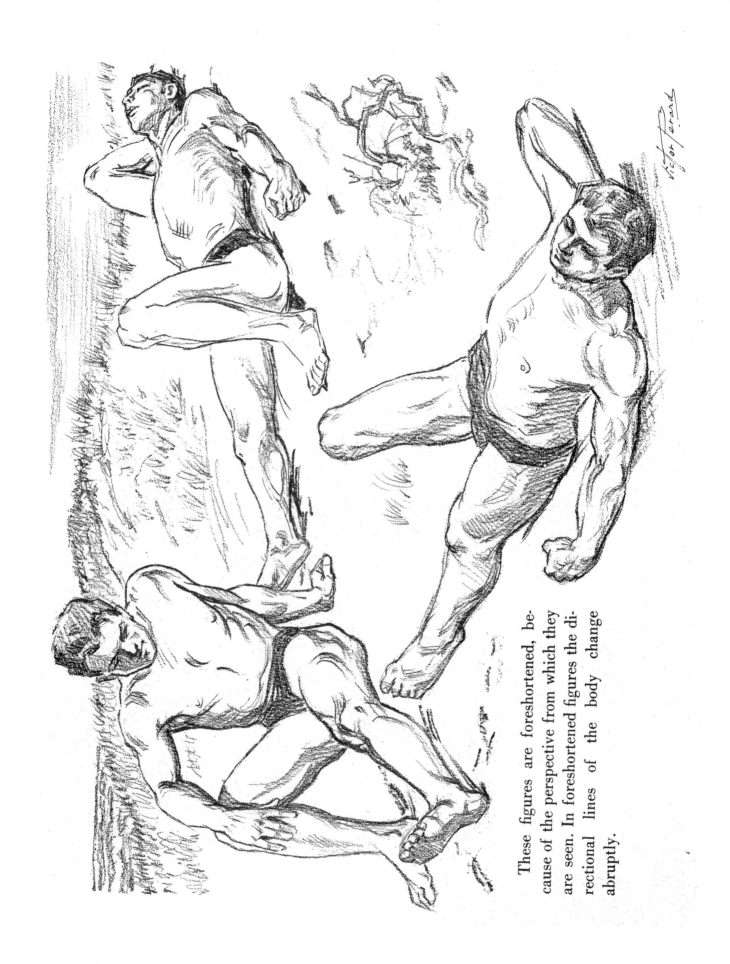

These figures are foreshortened, because of the perspective from which they are seen. In foreshortened figures the directional lines of the body change abruptly.

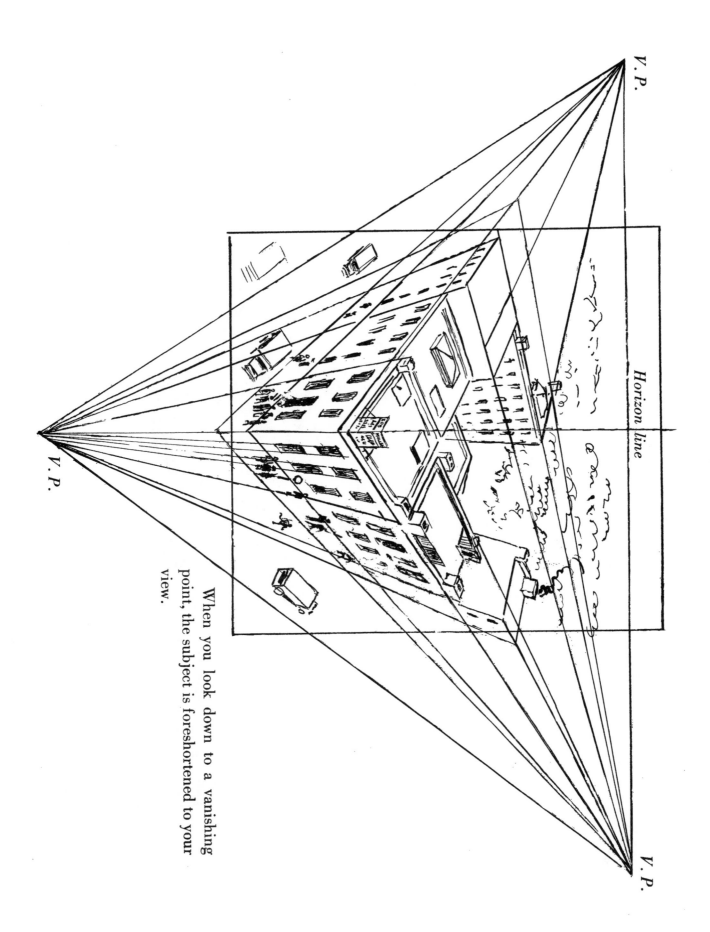

V.P.

V.P.

V.P.

Horizon line

When you look down to a vanishing point, the subject is foreshortened to your view.

When the vanishing points are beyond the margin of the paper, it is often advisable to build a grill with lines converging to a vanishing point. Place the grill over the paper. The grill then acts as a guide for directions of the lines.

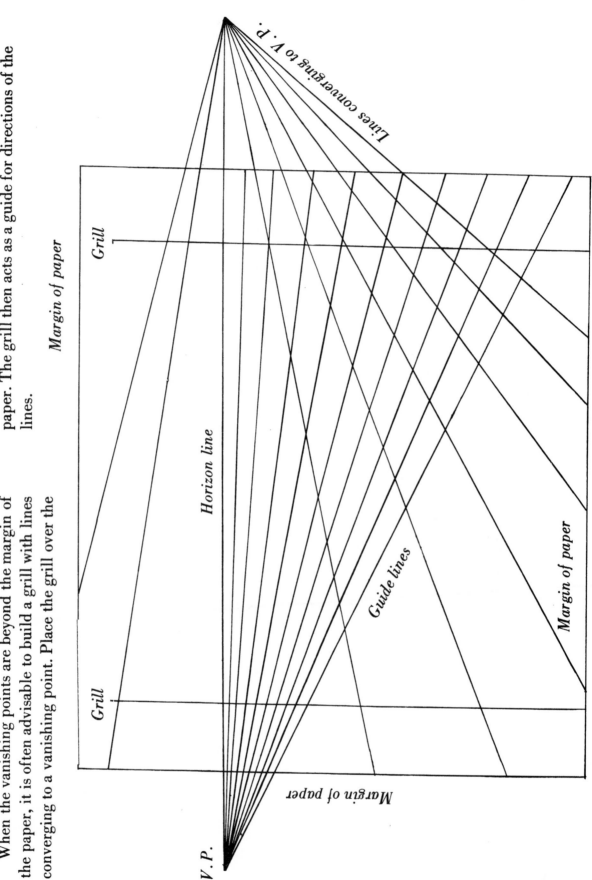

Lines converging to V. P.

Margin of paper

Grill

Horizon line

Guide lines

Margin of paper

Grill

Margin of paper

V. P.

First of all, select a suitable eye level (horizon) line, and then start the drawing freehand. Set the vanishing points. Then construct a grill on the left, divided into many equal segments. When perspective lines are drawn

from each of these segments across the page, it will be seen that the corresponding segments on the right-hand grill are much shorter. The vanishing point on the right is beyond the margin of the picture.

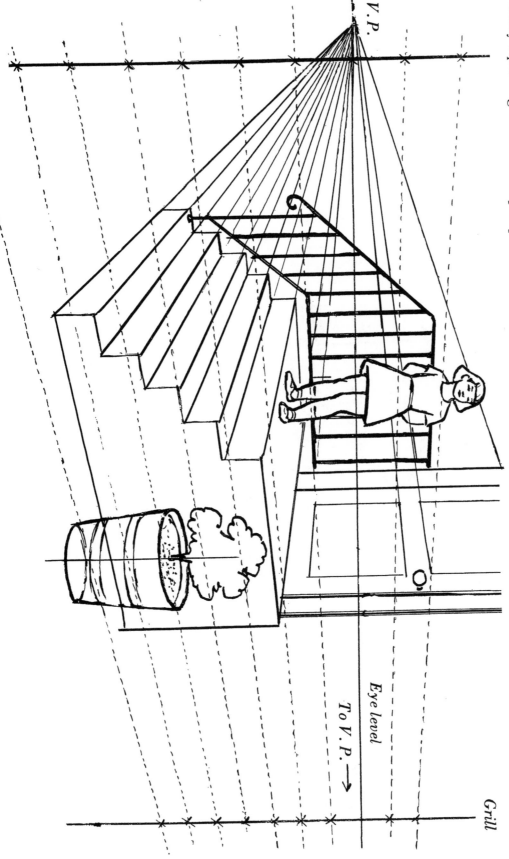

V.P.

Grill

Grill

Eye level

To V.P. →

Grill

A study in two point perspective

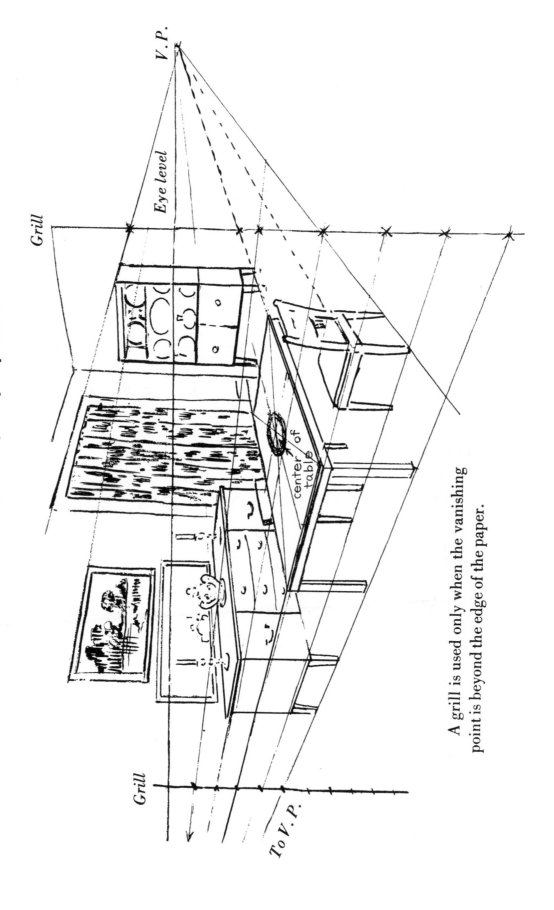

A grill is used only when the vanishing point is beyond the edge of the paper.

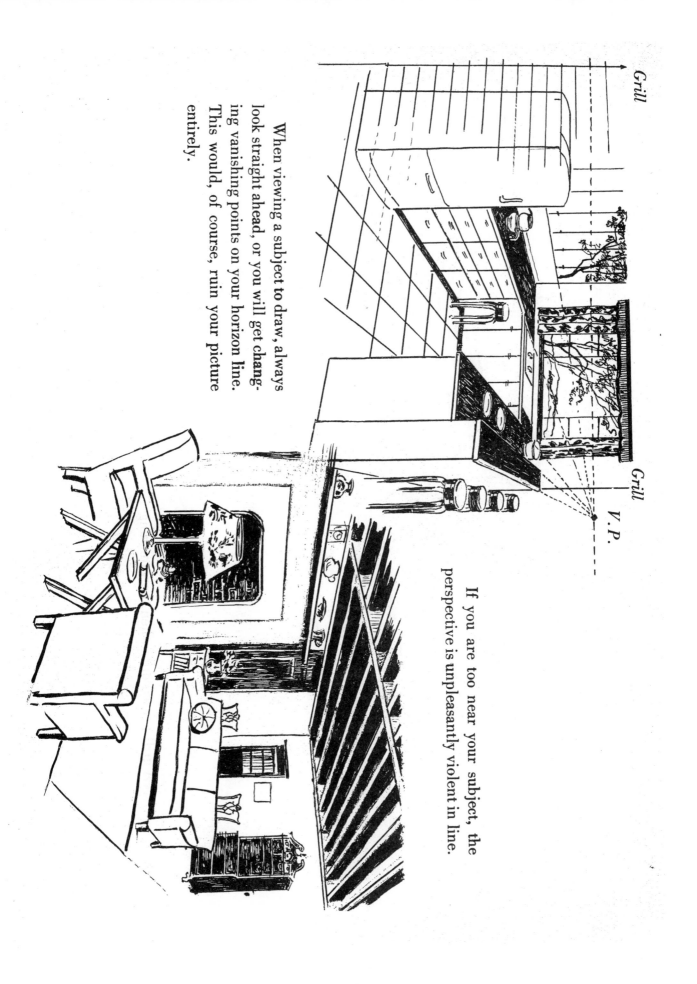

Grill

Grill V.P.

When viewing a subject to draw, always look straight ahead, or you will get changing vanishing points on your horizon line. This would, of course, ruin your picture entirely.

If you are too near your subject, the perspective is unpleasantly violent in line.

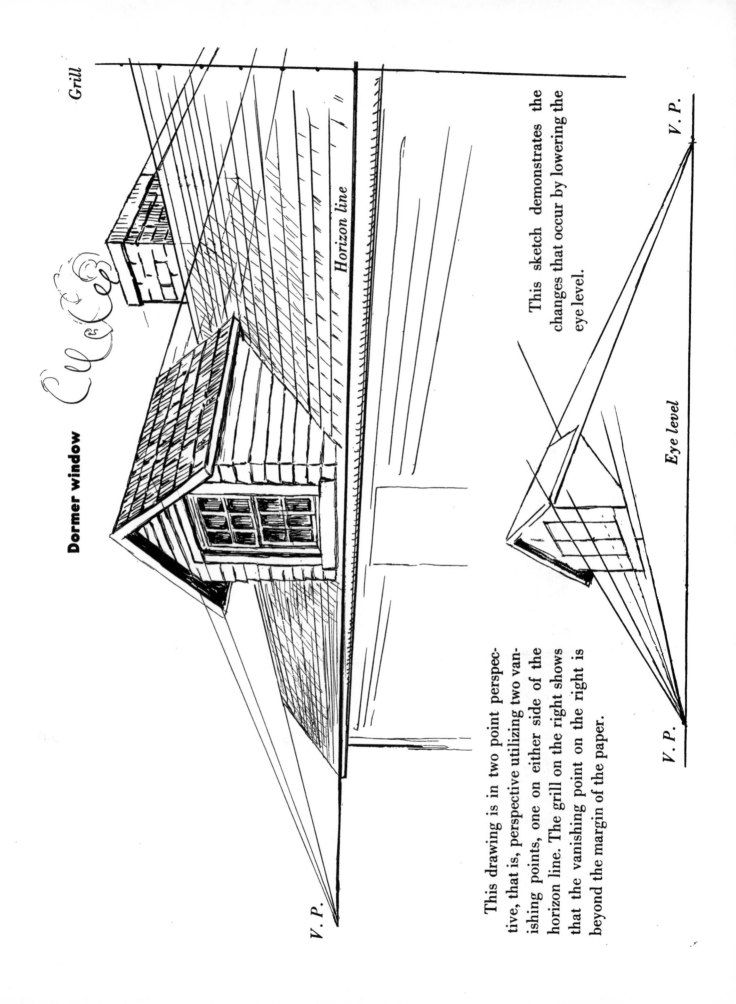

Grill

Dormer window

Horizon line

V. P.

This drawing is in two point perspective, that is, perspective utilizing two vanishing points, one on either side of the horizon line. The grill on the right shows that the vanishing point on the right is beyond the margin of the paper.

This sketch demonstrates the changes that occur by lowering the eye level.

Eye level

V. P.

V. P.

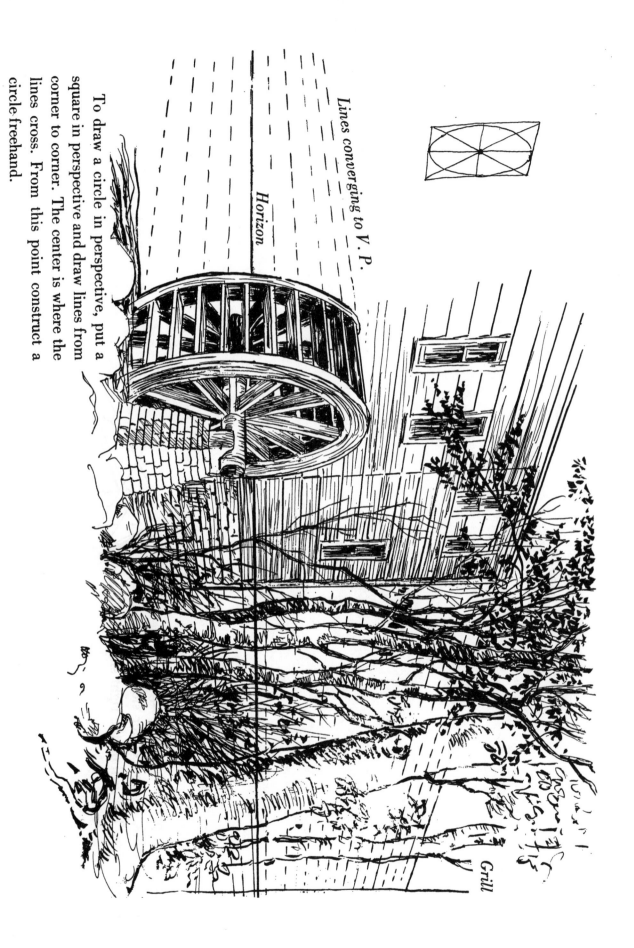

To draw a circle in perspective, put a square in perspective and draw lines from corner to corner. The center is where the lines cross. From this point construct a circle freehand.

Lines converging to V. P.

Horizon

Grill

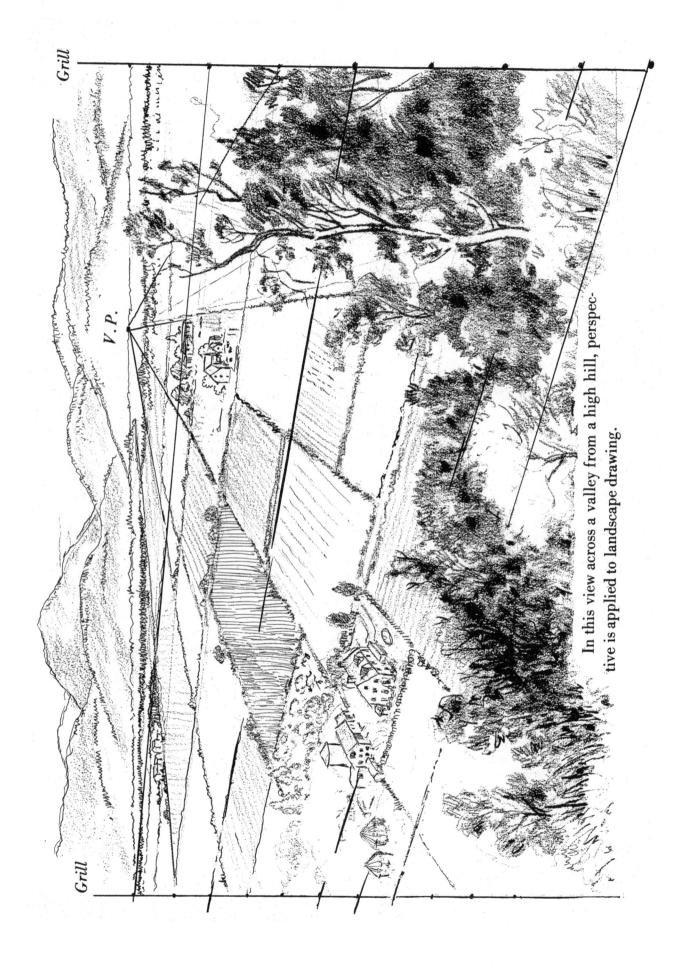

Grill

V.P.

Grill

In this view across a valley from a high hill, perspective is applied to landscape drawing.

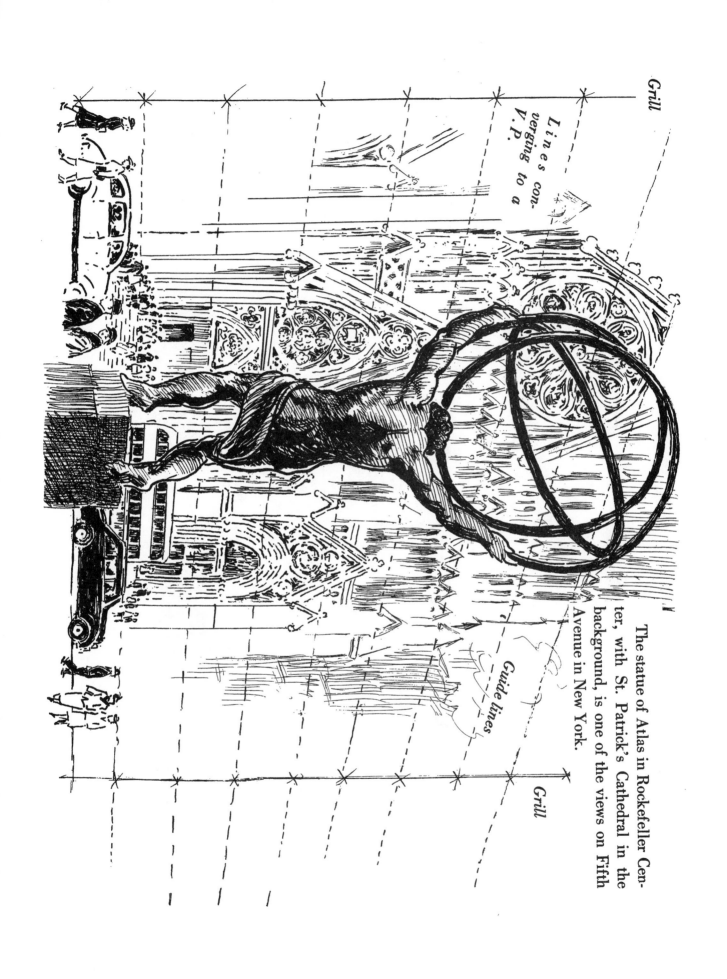

Grill

Lines con-
verging to a
V.P.

Guide lines

Grill

The statue of Atlas in Rockefeller Center, with St. Patrick's Cathedral in the background, is one of the views on Fifth Avenue in New York.

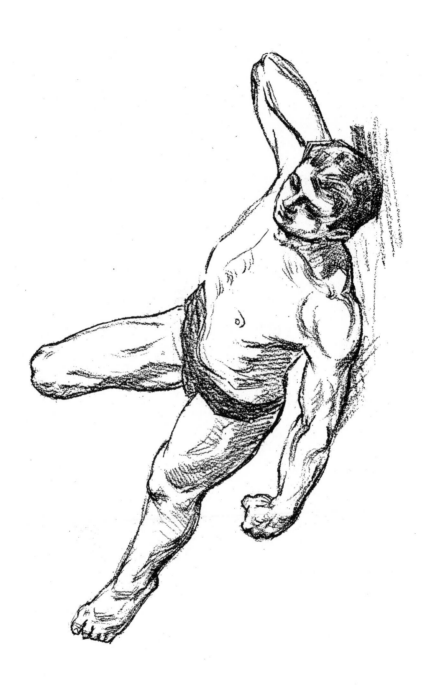